HENRY BANKES'S TREATISE ON LITHOGRAPHY

HENRY BANKES'S TREATISE ON

LITHOGRAPHY

Reprinted from the 1813 and 1816 editions
with an introduction and notes by
Michael Twyman

Printing Historical Society

London 1976

Published in 1976 by
The Printing Historical Society
St Bride Institute
Bride Lane, Fleet Street
London EC4

© Michael Twyman
ISBN 90000 307 3

Printed in Great Britain by
The Scolar Press Limited
59–61 East Parade
Ilkley
Yorkshire

CONTENTS

EDITORIAL NOTE

The pagination of the texts of the two original publications has been retained, and a line has been drawn beneath the folios of the 1816 edition in order to make a distinction between the two sequences. References to the texts in the editor's Introduction and Notes are given in roman (upright) figures where they relate to the 1813 edition and in italic figures where they relate to the 1816 edition.

Extensive passages of text which appear in one edition only, and significant differences between the texts, are indicated by vertical lines in the right-hand margins.

The conventional sign ◁ has been added in the right-hand margins to indicate a reference to the Notes at the back of the book.

The illustrations, which have been reproduced from three different copies of the 1813 edition, have been grouped together after the text of the first edition and have been lettered A to E for reference purposes.

The text of the 1813 edition of Bankes's treatise is reproduced from a copy in the Bodleian Library and that of the 1816 edition from the copy in Cambridge University Library. Plates A, B2 and C2 are also reproduced from the Bodleian Library copy. The remaining plates are from copies in a private collection (B1, C1), the Victoria & Albert Museum Library (D), and the Science Reference Library of the British Library (E). The lithograph by Bankes reproduced on page xi is in the Department of Prints and Drawings of the Victoria & Albert Museum, and the drawing of Bankes's press reproduced on page xxxix is in the John Phillips MS Collection of the University Museum, Oxford.

The Printing Historical Society wishes to thank the above mentioned for allowing these items to be photographed and for permission to reproduce them in this publication.

This publication contains facsimile reprints of both editions of Henry Bankes's treatise on lithography, the earliest independent work on the process in the English language. The first edition was published in Bath in 1813 with the title *Lithography; or, the art of making drawings on stone, for the purpose of being multiplied by printing*,[1] and the second edition in London in 1816 without the name of the author and with the title slightly changed to read *Lithography; or, the art of taking impressions from drawings and writing made on stone*.[2] Numerous accounts of the newly invented process of lithography, most of them very sketchy indeed, had already appeared in the scientific, literary, and artistic journals of Western Europe, but only one independent work on lithography preceded it – Heinrich Rapp's *Das Geheimniss des Steindrucks*, which was published in two editions in Tübingen and Schweinfurt in 1810.[3]

Bankes's treatise was one of five works on lithography written before the end of 1818, the year in which Alois Senefelder finally got around to completing the comprehensive account of his invention, which was first published in Munich and Vienna with the title *Vollständiges Lehrbuch der Steindruckerey*. Like most of the accounts of lithography which appeared before Senefelder's, it was not sufficiently detailed in its treatment of technicalities to satisfy all the requirements of the practitioner. Bankes may not have known enough about the process to be more explicit on technical matters but in any case, like many early writers on lithography, he was probably more concerned with publicising the process and preparing the way for those who practised it. Those who turn to Bankes's treatise – and particularly the 1813 edition – for precise technical descriptions of the methods of lithography as it was practised in the early nineteenth century will certainly be disappointed. The value of Bankes's treatise today is as an historical record of attitudes to the process in England in the period between its introduction right at the outset of the century and its revival by Ackermann, Hullmandel and others around 1818; and it is of particular interest for the few shafts of light it throws on those

associated with the process in Bath and on changing attitudes to lithography between 1813 and 1816.

As the title of the 1813 edition makes clear, the first English treatise on lithography was directed at the artist. It was written for those who might have been attracted by the opportunities offered by the new process for multiplying sketches, and was not intended as a technical manual of the kind which might be useful to someone who wanted to set up a press of his own. Consequently, Bankes limited his discussion to those things which would have been of interest to the draughtsman, and in his account of the actual methods of working he devoted special attention to instructions for making drawings on stone. In this connection it is worth noting that Bankes's book is one of the few early accounts of lithography to be limited to a description of the planographic branch of the process. Bankes made no mention at all of the variants of the process, some of them very complicated indeed, which occupy so many pages of continental accounts of lithography, but which would have been of little interest to the artist and even less to the amateur.

Unfortunately, we know virtually nothing about the author himself. Emanuel Green, who read a paper on 'Bath and early lithography' to the Bath Natural History and Antiquarian Field Club in January 1894, drew attention to Bankes's treatise,[4] but provided no information about the author of it. Bankes's name does not appear on the title-page of either edition, but is printed as 'H. Bankes' at the end of the text in the case of the first edition, followed by 'Bath, Sept. 18th, 1813'. We know, however, that his Christian name was Henry from the notices of the publication which appeared in the *Bath Chronicle* and *Bath and Cheltenham Gazette* (see below, p. xxi, note[1]).

Further clues to Bankes's identity come from a number of lithographs of the period, all very small and of no great artistic merit, which bear his name. Six lithographs in the Department of Prints and Drawings of the British Museum carry his name[5] and three others can be attributed to him by virtue of their style or subject[6] (two further prints in the British Museum which are attributed to him are, in my view, doubtful on stylistic grounds).[7] These lithographs include landscapes and seascapes with figures, and animal studies; they are very much in the Dutch manner and, apart from one which has a little chalk

work in the sky, are all ink lithographs. The six signed prints carry inscriptions which read as follows: 'H Bankes 1814', 'H Bankes', 'Henry Bankes from Weirotter', 'Henry Bankes from Waterloo', 'H Bankes 8 Maddox Street', 'Henry Bankes from Berghem printed from the Drawing on Stone 148 New Bond Street'. In the Victoria & Albert Museum there is a single print bearing two pen and ink landscape drawings, one of which is lettered 'Lithography/148 New Bond Stt.', and the other 'Mr Bankes/Drawn on stone/148 New Bond Stt'[8]

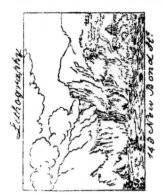

Overall dimension 64 × 134 mm

A further print in the John Johnson Collection of the Bodleian Library bears a set of what look like visiting cards, together with marginal drawings; it carries the words 'Mr Bankes/20 New Bond Stt.' on each of the four cards and is drawn in a combination of chalk and ink.[9] In addition, Felix Man lists an undated chalk lithograph from his own collection which bears the imprint 'H. Bankes del. printed by D. Redman Lithog.'.[10] The majority of these lithographs (I have not seen the one in the Man Collection which has recently passed to the Australian National Collection, Canberra) reveal a painstaking and rather hesitant use of the process reminiscent of the work of amateur etchers. Similar typographical conventions are found in the imprints of the Victoria & Albert Museum and Bodleian prints, and paper with the same 'SII' watermark was used for one of the British Museum prints and the single print in the Victoria & Albert Museum. There can be little doubt therefore that all these prints are the work of the same man.

Taken together, the imprints of these lithographs confirm that Bankes's Christian name was Henry, and that he was working as a lithographic draughtsman in 1814; they also tell us that Redman printed for him, and that he worked from at least three different addresses, one of them being 148 New Bond Street. That this Henry Bankes can be identified with the lithographic treatise under discussion is established by a note in Bigmore & Wyman: in their discussion of the copy of the 1816 edition of Bankes's treatise in the British Museum (since destroyed) they drew attention to an announcement at the end of the book which stated that 'the lithographic printing apparatus, with the stone and necessary materials' can be had of 'Mr. Bankes, 148, New Bond-street . . .'.[11]

A search for further information on Bankes in Bath directories and other local sources has so far done nothing but confuse the picture. The first area of doubt arises from a variant form of spelling of Bankes's surname, and the second from a coincidence of addresses. The three announcements of the 1813 edition of Bankes's treatise I have managed to trace in the *Bath Chronicle* and *Bath and Cheltenham Gazette* (see below, p. xxi, note[1]) all give the name of the author of the treatise as 'Henry Banks', without an 'e'. These two papers were produced by different printing houses, one of them, the *Bath and Cheltenham Gazette*, being printed and published at the City Printing-Office, 9 Union Street, Bath, by (amongst others) G. Wood – the printer of Bankes's treatise. This discrepancy in the spelling of the surname would by itself be of no great significance in a period when such variations were not unusual, were it not for the fact that a reference to an artist with the name 'Banks' appears in one of the local directories. In two editions of the *Improved Bath guide* (undated, but probably for 1812 and 1816), which Wood & Co. both printed and published, there is the following entry under the heading 'Artists': 'Banks, sculptor in miniature on shells, New Bond-street'. We cannot, of course, be sure that the author of our treatise is the man referred to here, partly because, as with other entries, no Christian name is given, and partly because of the spelling of the surname, but no mention can be found of a person with the name of 'Bankes' either in this directory or in the *New Bath directory* (1812), *Original Bath guide* (1815, 1816) and *Gye's Bath directory* (1819).

A further problem is posed by the address 'New Bond-street'. It is an

unkind coincidence that both Bath and London have a New Bond Street and that Banks and Bankes are recorded as having lived or worked in a street of this name. Banks, the sculptor in miniature, is listed in the *Improved Bath guide* as working from New Bond-street in Bath (though no number is given); and there are lithographs by Bankes which bear the address '148 New Bond St.' or '20 New Bond St' without stating the town. We can be fairly certain that the 148 New Bond Street is the London address because the road of that name in Bath is very short, and because of the announcement quoted above which appeared with the 1816 edition of Bankes's treatise which was published in London. Moreover, there is a manuscript note in what appears to be a nineteenth-century hand at the end of one copy of the 1813 edition of Bankes's treatise which reads 'No 148 New Bond Street London'. We cannot be so certain about the location of the '20 New Bond St' found on the print by Bankes in the Bodleian Library, though the fact that R. Horwood's *Plan of the cities of London and Westminster* (1792–99) shows 20 New Bond Street as being directly opposite number 148 lends support to the view that all the addresses referred to on Bankes's lithographs are London addresses. '8 Maddox Street', which appears on one of his prints in the British Museum, is less than a quarter of a mile from the two New Bond Street addresses in London. If Bankes did set up as a lithographer he must have done so discreetly, however, because no mention of him can be found in the London directories of the period, nor in the Poll Book for Westminster of 1818.[12] A search through the Rate Books of the Conduit Street Ward of the Parish of St George (which included both New Bond Street and Maddox Street) for the period 1810–1820 has likewise revealed no trace of Bankes.[13]

Needless to say, Henry Bankes is not listed in the standard reference works on artists. The catalogues of the Department of Prints and Drawings of the British Museum give dates of 1757?–1834 for him, though the entry is an old one (probably nineteenth century) and the source of this information is no longer known. Apart from the skeletal and somewhat confusing facts outlined above, nothing is known about Henry Bankes beyond what little emerges about him from a reading of his treatise.

What can be surmised is that Bankes's involvement with lithography began through a connection with D. J. Redman, the first native English

lithographic printer. Redman worked as an assistant to the two Germans who practised lithography in England after Senefelder's return to Germany, Philipp André (1801–5) and G. J. Vollweiler (1806–7), and shortly afterwards he was taken on by the Quarter-Master-General's Office in Whitehall to help get a lithographic press established there for the printing of maps, plans, circulars, and similar jobbing work.[14] Redman stayed at the Quarter-Master-General's Office for about five years, but at the close of 1812 or the beginning of 1813 decided to branch out on his own and set up the first lithographic press in England outside the capital in the fashionable city of Bath.

Why Redman chose to do this is not known, though it can be assumed that he was under some kind of patronage and was attracted by the prospect of profiting from the flourishing community of artists there and the interest in drawing taken by members of fashionable Bath society. While in Bath Redman printed lithographs drawn by numerous amateur artists,[15] as well as two collections of drawings by one of Bath's most respected professional artists, Thomas Barker. In 1813 Redman printed Barker's *Forty lithographic impressions of rustic figures*, and in the following year his *Thirty two lithographic impressions of landscape scenery*, which are the first important 'one-man' collections of lithographs to be published in this country.[16]

For a number of years Bath became the centre of lithography in England; indeed, it was for a time the only place where lithography was being used in this country for the multiplication of artists' drawings. But by October 1815 Redman was back in London where he continued to be active as a lithographic printer until at least 1823.[17] Redman's return to London, which was referred to by Thomas Fisher in an article largely devoted to him in the *Gentleman's magazine* for October 1815[18] and is further documented by an advertisement of Redman's dated 1 November 1815,[19] appears to have coincided with Henry Bankes's move to the capital and the publication of the second edition of his treatise there in 1816. The connection between Bankes and Redman appears to have ceased at this point, however, and all references to Redman were omitted from the 1816 edition of the treatise. In particular, the passage in the 1813 edition which mentions that a steel pen may 'be had of Mr. Redman' (p. 18) was changed in 1816 to read that a steel pen is 'made by Mr. Merril, watchmaker, Pemberton Row, Gough Square' (p. 21).

The texts of both editions of Bankes's treatise are printed here because they are short enough for this to be practicable and because the differences between them are significant enough to create a difference in flavour. These differences can be accounted for by three factors: first, the move of Bankes and Redman from Bath to London; second, Bankes's better understanding of technical aspects of the process in the intervening years; and third, a general shift of emphasis in attitudes to the process. The difference in flavour between editions is reflected in the change made to the subtitle from . . . *the art of making drawings on stone, for the purpose of being multiplied by printing* to . . . *the art of taking impressions from drawings and writing made on stone.* It can be described as a movement away from a view of lithography as no more than a means of multiplying an artist's, and particularly an amateur artist's, sketches to that of a process which has in addition to these autographic qualities at least one specific commercial application.

The passages in the first edition devoted to Redman (pp. 4–5) and Barker (pp. 11–12), which Bankes might have thought would be of no interest outside Bath, were excluded from the second edition. It was clearly Bankes's intention to make the book less parochial, and it must have been with this in mind that he included in the 1816 edition a very short and most uninformative paragraph on the development of lithography abroad (*p. 8*).

The second edition is more explicit on some technical points, particularly on the preparation of the ink and chalk (*pp. 21–3*), which were very cursorily treated in the 1813 edition (p. 14). This new passage is untypically detailed and the description of the German method of making ink and chalk, which can be traced to a specific source, suggests that Bankes had enlarged his understanding of the subject through reading as well as practice. The tantalizing reference to the portable press which he had designed (*p. 24*) is another indication that Bankes was more experienced in the practicalities of the process when he came to prepare the second edition for publication.

The shift of emphasis in Bankes's attitude to lithography between the publication of the two editions can be deduced from his removal of the paragraph addressed specifically to 'amateur artists, who may practice [*sic*] the lithographic art for their amusement and the delight of their friends . . .' (pp. 16–17), and by the addition of a section devoted to the

use of transfer paper (*pp. 14–16*), which he describes as being useful for the multiplication of handwriting as well as for landscape sketches. There was nothing particularly novel in the process of transfer lithography by this time – it had been in regular use on the continent for years and had been described in a number of publications, including an English one – but Bankes's inclusion of it here in relation to the multiplication of written documents indicates that he had broadened his view of lithography and now accepted its use for commercial purposes.

Bankes's revision of the text was done on a somewhat patchwork basis and this has led to certain inconsistencies. For instance, his reason for adopting the word 'Lithography' (p. 8, *p. 11*) instead of 'Polyautography' for the process 'with a view to confine the invention to what is strictly denominated the Fine Arts, or drawing as the first branch of them' is not entirely consistent with his acceptance of its capacity to multiply handwriting.

Bankes's treatise is one of the rarest of early works on lithography and has eluded some of the major libraries in this country as well as local Bath collections. I have managed to trace seven copies of the 1813 edition and only a single copy of the 1816 edition. Copies of the 1813 edition are to be found in the Bodleian Library (which has two copies, one lacking its plates), Bristol Public Reference Library, Library of Congress (Lessing J. Rosenwald Collection), Science Reference Library of the British Library (previously the Patent Office Library), Victoria & Albert Museum Library, and a private collection. The only copy of the 1816 edition known to me lacks all its plates and is bound up with other items in Cambridge University Library. The copy of the 1816 edition listed in the British Library catalogues can no longer be traced and is officially recorded as having been destroyed by bombing.

The rarity of the book is hardly surprising. It is a work of no great pretensions either in its content or appearance and, if we are to judge by contemporary publications produced by lithography, both editions were probably very small (Barker's *Rustic figures*, for instance, was published in an edition of no more than 200 copies and his *Landscape scenery* in as small an edition as 50). The process of lithography presented technical problems to some of its earliest exponents and, since both editions of Bankes's treatise involved the printing of illustrations, the number of copies available for publication may have

been limited by the vagaries of lithography.

The 1813 edition is described on its title-page as having two drawings, but four of the six copies with plates that have been traced have three lithographed plates. The copy in the Science Reference Library of the British Library, which has only one plate, has the words 'with two drawings' firmly obliterated by hand. The plate which appears most frequently is the pen and ink landscape with a figure (A), which is to be found in all but one of the illustrated copies that have been traced. Both chalk-drawn studies of figures exist in two versions, which are referred to here as B1 and B2, C1 and C2. The chalk hatching in plates B1 and C1 is more subtle and complex and considerably less stylized than it is in plates B2 and C2, and I take the former to be the original plates.[20] If we are to judge from copies that have been traced, the most common combination of plates was the landscape with a figure (A) together with versions B2 and C2 of the studies of figures. Details of the plates which appear in copies of the 1813 edition I have managed to trace are set out in the table below:

	A	B1	B2	C1	C2	D	E
Bodleian Library							
Bodleian Library	X		X		X		
Bristol Public Reference Library	X		X		X		
Library of Congress	X		X		X		
Science Reference Library of the British Library							X
Victoria & Albert Museum Library	X					X	
Private collection	X	X		X			

None of the plates in copies of the 1813 edition I have traced seem to relate to the one specific set of references to illustrations in the text (pp. 18–19); and the two chalk-drawn studies of figures (which out-number the other plates when all the copies which have been traced are taken together) could hardly have been intended to illustrate a passage of text which describes the way in which landscape drawings should be made on stone in pen and ink. The most likely explanation for this oddity is that the printing of the plates in sufficient numbers for the entire edition proved particularly difficult and that lithographs were used regardless of their suitability in order to make up sufficient illustrated copies.

The 1816 edition is described on its title-page as having 'specimens of the art'. No illustrated copy of this edition appears to have survived, though the missing copy listed in the British Library catalogues, which Bigmore & Wyman described, contained six plates. One of these was the illustration of Bankes's portable press, mentioned in the text and re-ferred to there as *'Plate IV'* (*p. 24*). No other plate is mentioned in the text and, rather significantly in view of the unsuitability of the plates used in surviving copies of the 1813 edition, all references to illustra-tions in the passage relating to the making of landscape drawings in pen and ink have been deleted (*pp. 24–5*). Bigmore & Wyman do not appear to have seen the 1813 edition (they erroneously described it as having been published in London and as having no more than a frontispiece by way of illustrations), but their comment on the plates of the 1816 edition was that they were 'executed in the most wretched manner . . .'.

However wretchedly the illustrations to the 1816 edition may have been produced, they are of considerable interest because it seems likely that they were printed by Bankes himself. Only two lithographic presses are known to have been working in England in 1816. One of these was the press at the Quarter-Master-General's Office in Whitehall, which would hardly have been an appropriate choice – even if it had been available to undertake such work – in view of the condescending reference to it in the text of the book (*pp. 7–8*). The other was the press which Redman had recently set up in London; though the removal of all references to him in the text seems to suggest that Bankes and he had parted company. An announcement (quoted by Bigmore & Wyman) which appeared at the end of the missing British Library copy of the

1816 edition stated that 'the lithographic printing apparatus, with the stone and necessary materials' may be obtained from Mr Bankes, and this seems to support the view that Bankes may have tried to set up a lithographic press for himself.

It is hoped that this facsimile edition of Bankes's treatise will help to bring to light an illustrated copy of the 1816 edition. If this happens, and if the owner is in agreement, the Printing Historical Society will publish all its plates, either in its *Journal* or in some other appropriate way.

There remains the question of the attribution of the drawings found in copies of the 1813 edition. Only one is signed and there is no indication of the identity of the artist or artists in the text of either edition. Emanuel Green referred to them as closely resembling the style of Thomas Barker,[21] and the similarity of some of the illustrations to Barker's work is striking. The pen and ink landscape with a figure (A) displays the same kind of free handling of the pen with pot-hook terminals to the strokes, and a similar combination of parallel hatching and serpentine lines to indicate tone, as do the plates of Barker's *Landscape scenery*. The fluid treatment of the edges of forms, such as trunks of trees, is similar in both works, and so too is the way in which sky and trees are considered as part of a visual and atmospheric entity.

The chalk-drawn lithographs of figures (B1, B2, C1, C2) can likewise be compared with Barker's plates for *Rustic figures* and chalk lithographs by him now in the British Museum, which they resemble in their feeling for voluminous form as well as in their subject matter. Though the two versions of both of the figure studies differ considerably from one another in their treatment, there are good stylistic reasons for assuming that all four lithographs are the work of Barker. In the copy of the treatise in a private collection (which contains plates A, B1, and C1) each of the plates carries the manuscript note 'Drawn on the Stone by Thos. [or T.] Barker Esq.' beneath the picture. These notes appear to have been written in the nineteenth century, possibly in the early nineteenth century, and are given added importance by the fact that this copy has belonged for at least a century to a family which has lived in Bath continuously for the last two hundred years. If illustrations A, B1, B2, C1, and C2 were drawn by Barker, which on stylistic and other grounds seems likely, it is strange that Bankes made no mention of them in the text when he referred to Barker's forthcoming publications

(pp. 11–12). This may perhaps be seen as a further indication that it was not the original intention to include these illustrations in the treatise. By contrast, plate D stands out as a thoroughly incompetent drawing. It lacks the assured and intelligent treatment of the foliage and trunk of the tree seen in illustration A. The hatching is stilted throughout and there has been no attempt to integrate the landscape with the sky, which is left entirely blank. It seems quite clear on stylistic grounds that this lithograph cannot be by the same hand as that responsible for the plates previously discussed and it is reasonable to suppose that it may be an early drawing by Bankes himself. The similarity in style between this and some of the small lithographs by Bankes mentioned above is sufficiently strong, particularly in the treatment of foliage and fore-grounds, to support this view. The final illustration to be considered, plate E, presents no problems of attribution. It is signed at the foot 'Henry Bankes from Waterloo' and is identical to a print in the British Museum.[22] The inclusion of at least one print known to have been by Bankes does, of course, support the attribution to him of plate D.

Bankes's book was one of the least influential of all lithographic treatises; it seems to have been very little known at the time, and I have been able to trace only two references to it in the literature of lithography published before the last quarter of the nineteenth century. The 1816 edition was alluded to in a note on lithography in the *Gentleman's magazine* for 1822,[23] and was used and acknowledged (though the name of its author was not revealed) as one of the major sources of information for the entry on lithography in the *Edinburgh encyclopaedia* of 1830.[24] Continental lithographers of the first half of the century seem to have been entirely ignorant of it, however, and there is no mention of either edition in the early bibliographies of lithography compiled by Marcel de Serres (1814), Peignot (1819), and Engelmann (1835–40).[25] Both editions are referred to by Richmond (1878), Bigmore & Wyman (1880), Singer & Strang (1897), the Pennells (1898), Kampmann (1899), and Levis (1912),[26] and by the close of the nineteenth century it had acquired the importance of a bibliographical curiosity.

Notes

1. The book was announced as being 'In the press, and in a few days will be published' in the *Bath Chronicle* (9 Sept. 1813) and the *Bath and Cheltenham Gazette* (29 Sept. 1813). The following announcement appeared in the *Bath and Cheltenham Gazette* (20 Oct. 1813): 'This Day is published, price 2s. 6d. Lithography, or the Art of Drawing on Stone, for the purpose of being multiplied by Printing; communicated by Mr. Henry Banks [*sic*]. Bath, printed by Wood and Co. at the City Printing-office; and to be had of the booksellers in London & Bath.' The title was given in the same form in the other announcement in the *Bath and Cheltenham Gazette*, but the *Bath Chronicle* gave the title as it appeared in the publication, with minor differences in punctuation.

2. The 1816 edition of Bankes's treatise was published by Longman, Hurst, Rees, Orme, & Brown, but a search in the Longman Archives has failed to reveal any mention of the book. Comprehensive records for the period of Bankes's treatise survive; they are carefully ordered and indexed and, in theory, entries were made for every book published by Longman. The apparent absence of any reference to the book remains a puzzle.

3. For a discussion of the early literature of lithography, see M. Twyman, *Lithography 1800–1850* (London, 1970).

4. E. Green, 'Bath and early lithography', *Proceedings of the Bath Natural History and Antiquarian Field Club*, vol. viii, no. 1, 1897, pp. 30–1. Emanuel Green was a well-known local antiquarian. At his death his library, which contained copies of both editions of Bankes's treatise, was divided between a number of west-country libraries. The copy of the 1813 edition in Bristol Public Reference Library once belonged to Green.

5. English Lithography c. 260*, and 190* b1, f. 116; b2, f. 62.

6. 190* b1, f. 116; b2, f. 62. The nine prints by Bankes in the Department of Prints and Drawings of the British Museum were acquired at different times between 1852 and 1876, five of them are to be found in the Polyautographic Albums which were assembled by Thomas Fisher very much earlier (see Twyman, *op. cit.*, note pp. 30–1).

7. 190* b2, f. 50.

8. Department of Prints and Drawings, ES.100.A.

9. Reproduced in *Journal of the Printing Historical Society*, no. 8, 1972, pl. xxiii (a).

10. Item 14, F. Man, 'Lithography in England (1801–1810)', in C. Zigrosser, *Prints*, (London, 1963).

11. E. C. Bigmore and C. W. H. Wyman, *A bibliography of printing* (London,

1880), p. 34. See note to *p. 21* of the 1816 edition.

12. *The poll book, for electing two representatives in Parliament for the City and Liberty of Westminster, June 18, to July 4, 1818* (London, 1818).

13. Westminster City Archives. In the period 1810–20 rates were paid for these properties as follows: 148 New Bond Street (1810 Shackle & Blakey, 1811–15 Ernestina Blakey, 1816–19 William Sevestre, 1820 Henry Holman Criddle); 20 New Bond Street (1810 Pritchard Polley & Co., 1811–12, 1815–17 J. Pilton, 1818–20 Thomas & Giles Redmayne); 8 Maddox Street (1810–12 John & James Alcort, 1813–18 Mary Juggin, 1819–20 George Davies). None of these people is known to have had any connection with lithography, and it must be assumed that Bankes rented accommodation at these addresses. It will be noted that William Sevestre (who was described in the 1818 *Poll book* as a Jeweller) took over the property at 148 New Bond Street in the year in which Bankes announced that lithographic materials were available from him at that address. The 'J. Pilton' listed in connection with 20 New Bond Street may possibly refer to two different people, John and James Pilton. It is not clear from the rate books who owned the property in some years: in the 1813 entry in the rate books there appears the note 'Summonsd-Bankrup', and no Pilton was officially listed for the period 1813–15; in 1817 the property was described as being empty.

14. See Twyman, *op. cit.*, pp. 32–7.

15. Many of which are to be found in the Polyautographic Albums in the Department of Prints and Drawings of the British Museum (190*, b1, 2).

16. For further information, albeit scanty, about the work of Redman at Bath, see T. Fisher, 'Curious specimen of polyautography, or lithography', *Gentleman's magazine*, vol. lxxxv, October 1815, p. 297; Green, *op. cit.*, pp. 32–3; Twyman, *op. cit.*, pp. 35–6.

17. See Twyman, *op. cit.*, p. 36.

18. Fisher, *op. cit.*, pp. 297–8.

19. British Museum, Department of Prints and Drawings, 190* b2, f. 2.

20. Lithographs B2 and C2 are also to be found printed side by side on a single sheet of flimsy paper in the Polyautographic Albums of the Department of Prints and Drawings of the British Museum (190* b1, f. 77).

21. *Op. cit.*, p. 31.

22. Department of Prints and Drawings, 190* b2, f. 62.

23. 'Lithography', *Gentleman's magazine*, supplement to vol. xcii, part 2, 1822, pp. 627–8.

24. 'Lithography', *Edinburgh encyclopaedia*, vol. xiii, 1830, pp. 44–7.

25. M. de Serres, 'Notice sur la lithographie, ou sur l'art d'obtenir une impression avec la pierre', *Annales des arts et manufactures*, vol. li, Paris, 1814, pp. 317–18; G. P[eignot], *Essai historique sur la lithographie* (Paris, 1819); G. Engelmann, *Traité théorique et pratique de lithographie* (Mulhouse, 1835–40).

26. W. D. Richmond, *The grammar of lithography* (London, 1878); E. C. Bigmore and C. W. H. Wyman, *A bibliography of printing* (London, 1880); H. W. Singer and W. Strang, *Etching, engraving and the other methods of printing pictures* (London, 1897); J. & E. R. Pennell, *Lithography & lithographers* (London, 1898); C. Kampmann, *Die Literatur der Lithographie von 1798–1898* (Vienna, 1899); H. C. Levis, *A descriptive bibliography of the most important books in the English language relating to the art & history of engraving and the collecting of prints* (London, 1912).

LITHOGRAPHY;

OR,

THE ART OF MAKING

Drawings on Stone,

FOR THE PURPOSE OF BEING

MULTIPLIED BY PRINTING.

WITH TWO DRAWINGS.

Printed by Wood and Co. at the City Printing-Office,

AND SOLD BY THE

BOOKSELLERS OF BATH, CHELTENHAM, &c.

1813.

Price 2s. 6d.

LITHOGRAPHY;

OR, THE ART OF

Making Drawings on Stone.

THE art of taking impressions from Drawings made on Stone, is said to have been discovered by a gentleman of Munich, M. Aloisius Senefelder, and by him communicated to Mr. André, who applied it to the printing of music with great success at Frankfort. Mr. P. H. André, his son, a merchant in London, first introduced the art into this country about the year 1801, and entered a caveat

A 2

in the Patent-Office, to secure, if necessary, the advantages of the exclusive exercise of the invention to himself; but he took out no patent lest the process should be discovered by the specification he would be obliged to make. Mr. P. H. André communicated the capacities of the art to all the most eminent masters in London, and obtained from them many fine drawings on the stone, which he proposed to publish in numbers, containing six impressions at half-a-guinea each.

Some circumstances of his business, as a merchant, rendered it necessary for Mr. André to leave this country for Germany, and he was succeeded in the practice of the newly discovered art by Mr. G. J. Volweiller, who had been an assistant to the elder Mr. André, and therefore very competent to conduct and improve the establishment in England. Accord-

ingly, a series of numbers were published, containing thirty-six drawings, by the first draughtsmen in the country, viz.

BENJ. WEST, ESQ; P.R.A.	J. H. SERRES
H. FUSELI	W. HAVELL
T. BARKER	H. SINGLETON
SIR ROBT. KER PORTER	R. HILLS
J. BARRY	G. SAMUEL
W. DELAMOTTE	F. F. MANSKIRSH

AND OTHERS.*

This work, however, had a very confined sale, and the art was far from being in a state likely to obtain any great success in this country, chiefly owing to its more valuable capacities not being sufficiently brought forward and explained to the public, when Mr. Volweiller, being disappointed in his expectations, returned to Germany in August, 1807.

* The stones upon which these drawings are made, and the drawings themselves, in a perfect state, are now in the possession of Mr. BANKES, who proposes to re-publish them in Parts, containing Twenty Drawings, at £1. 1s. each; or in Numbers, containing Five Drawings, at 7s.

Since that time the art has been wholly neglected, for I cannot consider the use of it in the Quarter-Master-General's Office, at the Horse-Guards, for the printing of plans of battles and maps of the seat of war, any application of it favorable to its encouragement as a branch of the fine arts; although I am ready to allow that even this employment of the invention has been the means of preserving it to the country.

Mr. D. Redman, the person who performed the printing for Government, had been an assistant to Messrs. André and Volweiller, and was certainly competent to the business in the Quarter-Master-General's Office; but he received so very inadequate a salary for his services, that great pecuniary embarrassment would soon have compelled him to relinquish this employment for some other more productive

of the means of support for himself and
family. He has, however, been saved to
the art, and is now settled in the city of
Bath, under the patronage of the artists
there, and at the service of the public, to
provide the necessary materials, viz. the
ink and pencil, and to prepare the stone,
and take the impressions from drawings
made on it.

The editor of this little sketch of the
history of the art has no materials for any
larger account: he will therefore proceed
to describe the theory of the invention.

It is required that the stone should be
calcareous, of a compact smooth texture,
susceptible of polish, and absorbent of
water.

The tracings of the drawing are re-
quired to be made with an ink oleaginous

or greasy in its nature, or with a crayon of analogous qualities; either to be capable of resisting the action of water.

To take an impression from the drawing made on the stone, it is first washed over with water, this runs off the tracings and only remains on such parts of the stone left uncovered; it is then dabbed with the printer's ink, which being also greasy, is resisted by the watered parts of the stone, and received only by the tracings; the paper upon which the impression is to be taken is then laid upon the stone, the pressure of a screw or rolling-press applied, and the imprint taken.

The stone first brought into this country by Mr. André, was supposed to be peculiar to Germany; but it has since been discovered that it is precisely the same as the *White-Lias*, or Layer, found in such

great abundance in the immediate neigh-
bourhood of Bath, being the stratum lying
under the blue-lias, or layer, which is used
for burning into lime, paving the streets,
and coarse walling. The white-lias is not
so favorable for any of these purposes, and
is therefore thought of very little value,
except where the other cannot be got.

For the purpose of Lithography, how-
ever, no other stone is so eligible. Its
application to this art, therefore, will give
it a new value, and claim for it a greater
share of attention. It takes a very good
polish, is compact, fine grained, and ab-
sorbent of water. It may be procured of
any superficial dimensions required.

Previous to my entering more minute-
ly into the practice of the art, I shall notice
its more prominent and obvious capacity,
viz. that of multiplying the drawing from

the hand of the master. It was with reference to this capacity, that Mr. P. H. André introduced the art, under the title of Polyautography, and intended to apply it to all the purposes of engraving. I have taken the liberty, however, to change this for Lithography, with a view to confine the invention to what is strictly denominated the Fine Arts, or drawing as the first branch of them. For it is my opinion that its capacity to multiply fac similes can only be advantageously applied to this purpose. It never can equal an engraving on copper for multiplying copies of writing, or indeed answer any purpose to which the graver is applied. But it has a higher destination, from which it ought never to be diverted. What a rich inheritance might have descended to us if the old masters had possessed this art! The high price now so justly attached to their drawings and first sketches, is sufficient evidence

of the estimation in which they are held.
The finest etchings or engravings from any
such drawings or sketches are, at the best,
but translations from one language into
another, and never can give the spirit of
the original. It is impossible not to feel
how much benefit would have been de-
rived to the fine arts from the multiplica-
tion of the drawings of the masters and
their universal diffusion. Whatever the
poet has effected by means of the press,
the painter would have achieved with the
same facility.

Those rapid effusions of the imagina-
tion, those spirited sketches and brilliant
first thoughts, never perhaps realized even
in the finished painting—by this invention
might have been given to the world with
unlimited liberality; the facility of the
work, and the cheapness of the process,
dissipating every difficulty that prevented

the master so satisfactorily multiplying his drawings.

How many works of topographical description, or discovery in natural history, have been imperfectly illustrated for want of drawings, which this art might have afforded at an expense no longer an objection; and how many amateurs of the fine arts, whose fortune and situation in life gave them access to whatever is interesting and curious, might have been inclined to communicate to the world their selections, if they had possessed this art.

The stock of fine ideas would have been so multiplied that the general taste could not but have been improved to the highest degree, and drawing well become as easy to be attained as writing well.

Although the general capacity of the

art is indeed adapted to many valuable purposes, there is none so much so, in my view of it, as the *multiplying the drawings of our best masters;* and it is principally to excite the attention of the public to this use of the art that the present communication is made; and let it ever be remembered that the productions of the lithographic press will be *fac similes* of what is excellent, *multiplied originals,* instead of spiritless copies.

And here I have a particular pleasure in noticing Mr. Thomas Barker's intended publication of impressions from his drawings of picturesque figures on stone, chiefly selected from his studies from nature. As this work is the first that has been undertaken of so much importance on the stone, and as it will more particularly illustrate the capacity of the art, the value of which I have endeavoured so

strongly to point out, I trust it will obtain that patronage which may induce Mr. Barker to pursue his intentions of giving other specimens of his drawings to the public, multiplied in the same manner; for nothing will tend more to promote the success of the lithographic art than its appropriation to such works, and it is unnecessary to repeat how valuable they will be in the view I have already considered them.

I understand it is Mr. Barker's intention, if successful in his present undertaking, to publish impressions from his drawings of landscape scenery and studies of figures made in Italy.

I will not waste my reader's time, or my own, in discussing an objection to the art arising from its probable abuse, or the equally futile but more contemptible one, that it may prejudice the value of the

works of the masters by diminishing their rarity. The first objection applies to every sort of printing, whether from copper plates, wooden cuts, or types. The second is founded in prejudice and a base feeling not belonging to the man of true taste, to whom only I address myself.

For those who may be induced to practice this art, it may be necessary to make the following memorandums:—

First, that the stone should be made perfectly level on its surface, of equal thickness, and if for the pen and ink, with a good face approaching towards a polish. This is effected by means of pumice stone and water.

If it be intended to use the crayon or pencil to imitate the effect of a chalk

B

drawing, it will be necessary to granulate the surface of the stone, which is effected by means of fine sand and a hard muller.

The ink is a combination of wax,* shell lac, and lampblack, in aqueous solution by means of soda. The crayon is formed of the same materials, leaving out the water and consequently the soda.

Previous to drawing on the stone, it is indispensably necessary that every particle of dust should be carefully removed from its surface, lest the tracings should be intercepted, and so not sufficiently adhere to the stone. It is also necessary to dry the stone by the fire as perfectly as possible, and to use it in some degree warm.

* A small quantity of tallow is previously added to the wax.

The bare hand, should on no account, be permitted to touch the stone after being made ready for drawing upon, for this would grease it, and in the printing discover itself.

That the effect of gradation of tint being produced wholly by regulating the breadth of the line of the tracings, and not by their strength of tone, this must be particularly attended to, whether the pen or crayon be used, and the repetition of strokes avoided.

After the drawing is completed on the stone, it is necessary to place it over a trough of water, and pour over it a very slightly acidulated water, (by means of the nitric acid) which will, but to an almost imperceptible degree, lower the surface of the stone where free from the

tracings of the drawing; a weak solution
of gum arabic is then applied, which has
the effect of closing the open pores, and
keeping the stone in a proper state of
moisture for printing from. Thus prepared,
the stone is taken to the press, and being
washed over with water, the printer's dab-
ber is applied, with the ink made extem-
pore of lampblack, previously well ground,
and linseed-oil prepared as for copper-
plate ink. This ink being also greasy is
resisted by the watered parts of the stone,
but received by the tracings, upon which
no water can lie; and being thus filled
with ink, damp paper is laid over the stone,
the pressure of a rolling or screw press is
applied, and an impression taken. The
process of watering, dabbing with ink, &c.
is then repeated, another impression is
taken, and so on for any number required.

I shall conclude these memorandums

with one I consider very important to be attended to by amateur artists, who may practice the lithographic art for their amusement and the delight of their friends, viz. that they do not on any account give their drawings any thing like the character of engraving; this would cramp the hand, fetter the genius, and considerably diminish the value of the work : let them take the stone, when prepared, and, as if they were to draw on paper, proceed with the same freedom and spirit. Little errors are easily corrected or obliterated by means of a sharp eraser.

The original drawing may be first done on paper in red chalk, which is better than any other material; and then transferred by laying it on the stone and rubbing the back with a burnisher. It will thus be properly reversed on the stone for being impressed in printing the right way.

A crow-quill pen is perhaps the best that can be used with the ink; the slit must be long, and the nib of a breadth proportioned to the drawing required. A Chinese hair pencil may be used advantageously where very fine strokes are required, and a steel pen (to be had of Mr. Redman) may also be occasionally used.

IN order to render this little essay as useful as possible to those for whom it is intended, I will venture to offer the following instructions for drawing with the pen, as applied to landscape:—

Begin with the extreme distance, and use a pen that has a very fine nib and a long slit to carry the ink: draw the contours of objects only as they appear in mass, as broad as possible to give the effect of distance.—*Example* 1 *in plate* 2.

With a somewhat broader-nibbed pen
put in the middle distance; and, in addi-
tion to the simple contours of objects,
enter a little into the detail of their larger
masses.—*Example 2 in plate 2.*

On the foreground use a still broader
pen, and give every object its local cha-
racter and form in correct detail, which is
the only mode of giving the effect of near-
ness, while it also tends to throw the other
parts of the drawing back.—*Example 3
in plate 2.*

As there is no such thing as outline
in nature, the lines by which we describe
the forms of objects should be as much as
possible confined to their shade side; and,
as shadows always lie underneath, it is
particularly to be remembered to begin by
tracing the contours of masses at this part;
for instance, in the foliage of trees the

whole must be made out in the manner shewn in example 3 above referred to.

The shadows in general should be expressed by parallel straight lines which have no local character, but more particularly in the distance. On the foreground, the transparency of shadows will be better preserved by tracing out the forms of the objects in a broader stroke of the pen. It adds to the harmony of the drawing that the shade lines should all go one way as much as possible.

The sky may be done last, and little more is necessary than a few clouds to prevent the disagreeable effect of so large a portion of the drawing being as it were a blank. Let it be remembered, however, that there is a rule for drawing these clouds; their shade tint must be produced by parallel lines gently waving and deviating from the line of the horizon.

The principle upon which the outlines of a pen and ink or pencil drawing in black and white are filled up, is called the mezzo-tento, or middle tint, or the tint between light and shade:* it is best produced by straight parallel lines of different degrees of strength. This tint, however, is not used on the foreground, where the light should be in undiminished strength.

It is particularly recommended that the whole of the drawing should be made with as few lines as possible in the first in-stance. It is a perfection in drawing to give the local character of any object by as few touches as possible: and there is an advantage in this mode, in the opportunity it gives of promoting the effect of aërial perspective, by more amply making out

* The ground on which the drawing is made being the light, the outlines the shade.

the objects near to you, and where the strongest lights are supposed to fall, in finishing.

The first state of a drawing is like the dead coloring of painting. The subsequent touches on the drawing bring it up to life like the second and third paintings of a picture, which improve the lights, strengthen the shadows, and make out local character. Indeed, it is a good plan to imagine that you are at first drawing with so little light that the contours of the masses can only be defined: then suppose a little more light, which exhibits them more in detail; and lastly, that sufficient quantity of light which makes every thing properly obvious.

To those who are well acquainted with the subject, these instructions are on my part a work of supererogation, but I trust

not impertinently intruded. They are founded at least on just principles, and on so rational a theory, that the art of drawing from nature may be much assisted by them, and the drawings of those who apply them have a masterly character.

H. BANKES.

Bath, Sept. 18*th,* 1813.

FINIS.

Wood and Co.
City Printing-Office Bath.

PLATES FROM COPIES OF THE 1813 EDITION

These illustrations are of plates from three different copies of Bankes's treatise (see the Editorial note). The images are reproduced the same size as the originals.

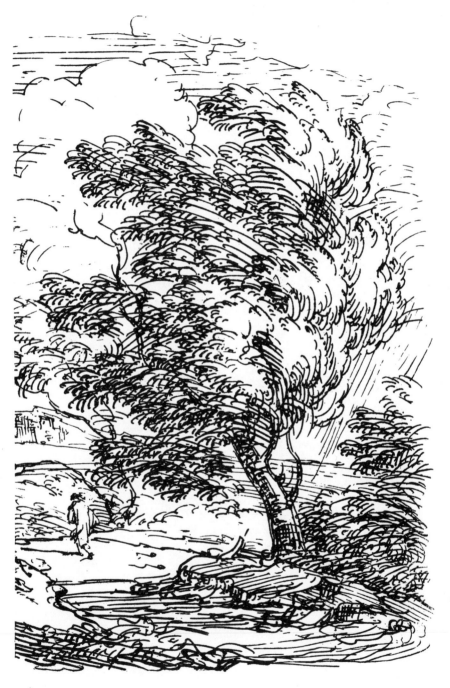

A

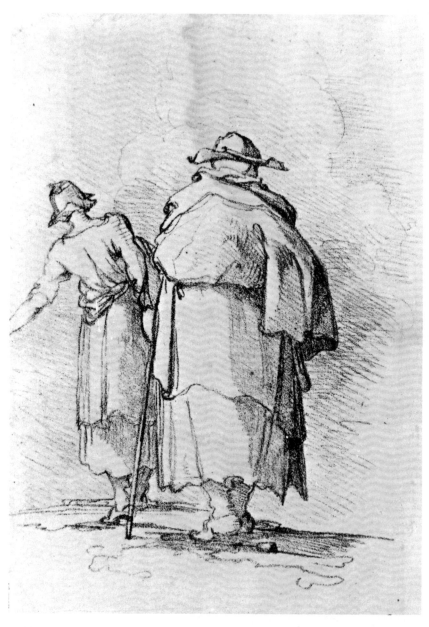

B1

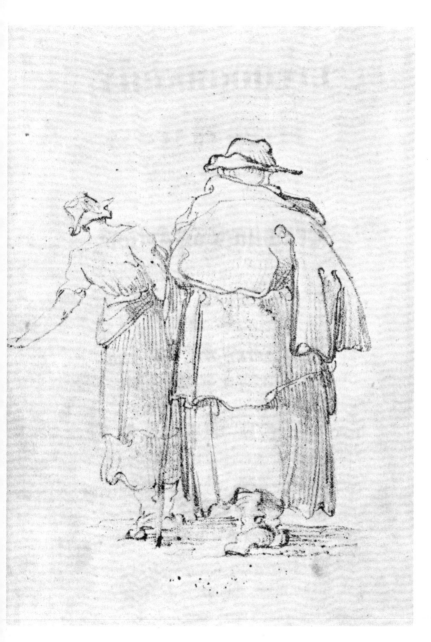

B2

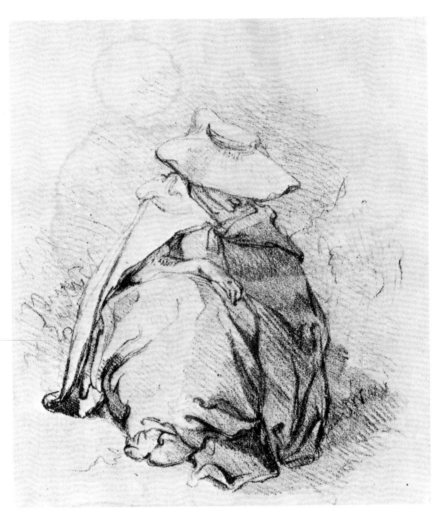

C1

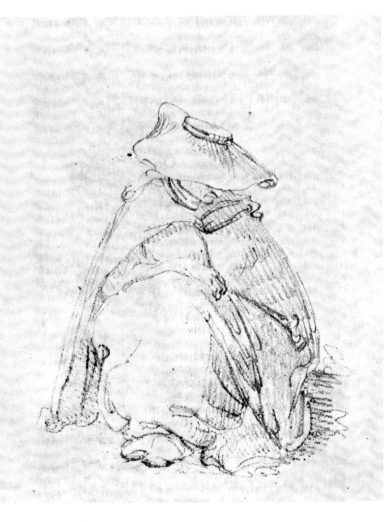

C2

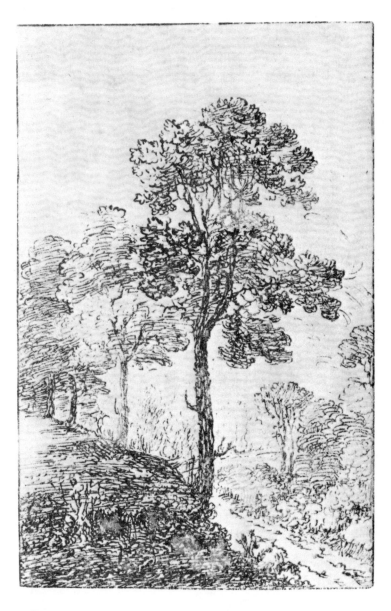

D

E

LITHOGRAPHY;

OR,

THE ART OF TAKING IMPRESSIONS

FROM

𝔇𝔯𝔞𝔴𝔦𝔫𝔤𝔰 𝔞𝔫𝔡 𝔚𝔯𝔦𝔱𝔦𝔫𝔤

MADE ON STONE.

———

SECOND EDITION.

LITHOGRAPHY;

OR,

THE ART OF TAKING IMPRESSIONS

FROM

𝔇𝔯𝔞𝔴𝔦𝔫𝔤𝔰 𝔞𝔫𝔡 𝔚𝔯𝔦𝔱𝔦𝔫𝔤

MADE ON STONE.

WITH

SPECIMENS OF THE ART.

SECOND EDITION,
WITH CONSIDERABLE ADDITIONS.

London:

Printed by MACDONALD & SON, 46, Cloth Fair,

AND PUBLISHED BY

LONGMAN, HURST, REES, ORME, & BROWN,

PATERNOSTER ROW;

1816.

Price Five Shillings.

𝕷𝖎𝖙𝖍𝖔𝖌𝖗𝖆𝖕𝖍𝖞;

OR,

THE ART OF TAKING IMPRESSIONS

FROM

DRAWINGS AND WRITING

MADE ON STONE.

———

THE Art of taking Impressions from Drawings made on Stone is said to have been discovered by a gentleman of Munich, M. Aloisius Senefelder, and by him communicated to Mr. André, who applied it to the printing of music with great success at Frankfort. Mr. P. H. André, his son, a merchant in London, first introduced the art into this country about the year 1801, and entered a caveat in the

B Patent-

Patent-Office, to secure, if necessary, the advantages of the exclusive exercise of the invention to himself; but he took out no patent, lest the process should be discovered by the specification he would be obliged to make. Mr. P. H. André communicated the capacities of the art to all the most eminent masters in London, and obtained from them many fine drawings on the stone, which he proposed to publish in numbers, containing six impressions, at half-a-guinea each.

Some circumstances of his business, as a merchant, rendered it necessary for Mr. André to leave this country for Germany; and he was succeeded in the practice of the newly-discovered art by Mr. G. J. Volweiller, who had been an assistant to the elder Mr. André, and therefore very competent to conduct and improve the establishment in England. Accordingly, a series of numbers were published, containing

taining thirty-six drawings, by the first draughtsmen in the country, *viz.*

BENJ. WEST, ESQ. P.R.A.	J. H. SERRES
H. FUSELI	W. HAVELL
T. BARKER	H. SINGLETON
SIR ROBERT KER PORTER	R. HILLS
J. BARRY	G. SAMUEL
W. DELAMOTTE	F. F. MANSKIRSH

AND OTHERS.

This work, however, had a very confined sale; and the art was far from being in a state likely to obtain any great success in this country, chiefly owing to its more valuable capacities not being sufficiently brought forward and explained to the public, when Mr. Volweiller, being disappointed in his expectations, returned to Germany, in August 1807.

Since that time, the art has been wholly neglected in this country; for I cannot consider the use of it in the Quarter-Master-General's Office, at the Horse-Guards, for the printing of plans of battles and maps of the seat of war, any ap-

B 2 plication

plication of it favourable to its encouragement as a branch of the fine arts; although I am ready to allow, that even this employment of the invention has been the means of preserving it to the country.

The Lithographic Art has been very successfully practised in Germany to the present moment. It has also been introduced into Italy, and lately into France.

The Editor of this little sketch of the history of the art has no materials for any larger account; he will therefore proceed to describe the theory of the invention.

It is required that the stone should be calcareous, of a compact smooth texture, susceptible of polish, and absorbent of water.

The tracings of the drawing are required to be made with a saponaceous ink, or

with

with a crayon of the same quality; either to be capable of resisting the action of water, when, by a chemical process hereafter described, the alkali is extracted.

To take an impression from the drawing made on the stone—After the tracings are rendered insoluble, it is first washed over with water; this runs off the tracings, and only remains on such parts of the stone as are left uncovered: it is then dabbed with the printer's ink, which, being also greasy, is resisted by the watered parts of the stone, and received only by the tracings. The paper upon which the impression is to be taken is then laid upon the stone, the pressure of a screw or rolling press applied, and the imprint taken.

The stone first brought into this country by Mr. André was supposed to be peculiar to Germany; but it has since been discovered

discovered that it is precisely the same
as the *white-lias*, or layer, found in such
great abundance in the immediate neigh-
bourhood of Bath, being the stratum lying
under the blue-lias, or layer, which is used
for burning into lime, paving the streets,
and coarse walling. The white-lias is not
so favourable for any of these purposes,
and is therefore thought of very little
value, except where the other cannot be
got. For the purpose of Lithography,
however, no other stone is so eligible. Its
application to this art, therefore, will give
it a new value, and claim for it a greater
share of attention. It takes a very good
polish, is compact, fine-grained, and ab-
sorbent of water. It may be procured of
any superficial dimensions required.

Previous to my entering more minutely
into the practice of the art, I shall notice
its more prominent and obvious capacity,
viz. that of multiplying the drawing from
the

the hand of the master. It was with re-
ference to this capacity, that Mr. P. H.
André introduced the art under the title
of *Polyautography*, and intended to apply
it to all the purposes of engraving. I have
taken the liberty, however, to change this
for *Lithography*, with a view to confine
the invention to what is strictly denomi-
nated the Fine Arts, or Drawing as the first
branch of them. For it is my opinion,
that its capacity to multiply fac-similes
can only be advantageously applied to this
purpose. It never can equal an engraving
on copper for multiplying copies of writing,
or indeed answer any purpose to which
the graver is applied. But it has a higher
destination, from which it ought never to
be diverted. What a rich inheritance
might have descended to us if the old
masters had possessed this art! The high
price now so justly attached to their draw-
ings and first sketches, is sufficient evidence
of the estimation in which they are held.
The

The finest etchings or engravings from any such drawings or sketches are, at the best, but translations from one language into another, and never can give the spirit of the original. It is impossible not to feel how much benefit would have been derived to the fine arts from the multiplication of the drawings of the masters, and their universal diffusion. Whatever the poet has effected by means of the press, the painter would have achieved with the same facility.

Those rapid effusions of the imagination, those spirited sketches and brilliant first thoughts—never perhaps realized even in the finished painting—by this invention might have been given to the world with unlimited liberality; the facility of the work, and the cheapness of the process, dissipating every difficulty that prevented the master so satisfactorily multiplying his drawings.

How

How many works of topographical description, or discovery in natural history, have been imperfectly illustrated for want of drawings, which this art might have afforded at an expence no longer an objection! and how many amateurs of the fine arts, whose fortune and situation in life gave them access to whatever is interesting and curious, might have been inclined to communicate to the world their selections, if they had possessed this art!

The stock of fine ideas would have been so increased, that the general taste could not but have been improved to the highest degree, and drawing well become as easy to be attained as writing well.

Although the general capacity of the art is indeed adapted to many valuable purposes, there is none so much so, in my view of it, as the *multiplying the drawings of our best masters;* and it is principally

to

to excite the attention of the public to this use of the art that the present communication is made: and let it ever be remembered, that the productions of the lithographic press will be *fac-similes* of what is excellent, *multiplied originals*, instead of spiritless copies.

I should not do justice to the art, however, if I omitted to suggest its capacity to multiply the hand-writing, and particularly the writing of those characters for which types are scarcely adequate, or at least much more expensively obtained—I mean, the characters of the oriental languages. The writer of these languages may, with the chemical ink, on a paper varnished with size or strong gum, complete his manuscript, which he may then transfer to the stone, and proceed with the printing from it, as if done at first on the stone, avoiding by this process all the difficulties of writing backwards, &c.

The

The draughtsman, too, may take his paper prepared into the country, make his sketches, and at his leisure transfer them to the stone, without the trouble of reversing the subjects; or, he may cover his pencil sketches with the size or gum, and trace over them with the prepared ink or chalk, and so transfer them to the stone.

To perform the transfer, the stone is heated to a moderate degree of heat by placing it before a fire, and the paper thoroughly damped on which the drawing has been made: the power of the printing press fixes the drawing on the stone.

The precautions to be used in effecting the complete transfer of the writing or drawing to the stone are, to take care that the stone be of sufficient heat, the paper on which the drawing is made well covered with the gum or size, and, with the drawing

drawing on it, soaked in water previously to being placed on the stone to be passed through the press. A size made of gum tragacanth and starch I find to answer better than any other.

I will not waste my reader's time, or my own, in discussing an objection to the art arising from its probable abuse, or the equally futile but more contemptible one, that it may prejudice the value of the works of the masters by diminishing their rarity. The first objection applies to every sort of printing, whether from copper-plates, wooden cuts, or types. The second is founded in prejudice and a base feeling not belonging to the man of true taste, to whom only I address myself.

For those who may be induced to prac-tise this art, it may be necessary to make the following memoranda :—

First,

First, that the stone should be made perfectly level on its surface, of equal thickness, and if for the pen and ink, with a good face approaching towards a polish—this is effected by means of pumice stone and water.

If it be intended to use the crayon or pencil, to imitate the effect of a chalk drawing, it will be necessary to granulate the surface of the stone; which is effected by means of fine sand and a muller, or flat piece of marble.

Previous to drawing on the stone, it is indispensably necessary that every particle of dust should be carefully removed from its surface, lest the tracings should be intercepted, and so not sufficiently adhere to the stone. It is also necessary to dry the stone by the fire as perfectly as possible, and to use it in some degree warm.

The

The bare hand should on no account be permitted to touch the stone after being made ready for drawing upon; for this would grease it, and in the printing discover itself.

That the effect of gradation of tint being produced wholly by regulating the breadth of the line of the tracings, and not by their strength of tone, this must be particularly attended to, whether the pen or crayon be used, and the repetition of strokes avoided.

After the drawing is completed on the stone, and a sufficient interval elapsed for its becoming perfectly dry, it is necessary to place it over a trough of water, and pour over it a very slightly acidulated water (by means of the vitriolic acid); which will, by the laws of chemical affinity, take up the alkali from the saponaceous ink or chalk, and leave an insoluble matter behind, and also,

also, in an almost imperceptible degree, lower the surface of the stone where free from the tracings of the drawing. A weak solution of gum arabic is then applied, which has the effect of closing the open pores, and keeping the stone in a proper state of moisture for printing from. Thus prepared, the stone is taken to the press, and being washed over with water, the printers' dabber is applied, with the ink made *extempore* of lamp-black, previously burnt in a closed crucible, and well ground, with linseed oil prepared as for copper-plate ink. This ink being also greasy is resisted by the watered parts of the stone, but received by the tracings, upon which no water can lie; and being thus covered with ink, damp paper is laid over the stone, the pressure of a rolling or screw press is applied, and an impression taken. The process of watering, dabbing with ink, &c. is then repeated, another impression is taken, and so on for any number required.

The

The original drawing may be first done on paper, in red chalk, which is better than any other material; and then transferred, by laying it on the stone, and rubbing the back with a burnisher. It will thus be properly reversed on the stone for being impressed in printing the right way.

A soft black-lead pencil may also be employed. The more faintly either tracing is performed, so that it may be seen, the better; for the tracings of the chemical ink or chalk might otherwise be intercepted.

In the progress of the drawing, trifling errors may be corrected, by taking them out with the point of a penknife, and the place rubbed smooth with a piece of pumice-stone.

A crow-quill pen is perhaps the best that can be used with the ink; the slit

must

must be long, and the nib of a breadth proportioned to the drawing required. A Chinese hair-pencil may be used advantageously where very fine strokes are required; and a steel pen (made by Mr. Merril, watchmaker, Pemberton Row, Gough Square) may also be occasionally used.

The ink is, as before observed, a saponaceous compound, and may be made with great ease, and perfectly adequate to the purposes of the art, in the following manner:—Take any quantity of the article called *Heel* or *Shoe-ball*, sold by the persons called Grinders, who supply shoemakers with the materials of their business; add to this one-fifth of its weight of tallow, one-fifth of its weight of lamp-black, and one-fifth of its weight of soda : melt the whole together in a large iron ladle, and suffer the compound not only to boil, but to ignite for a minute or two. When completely dissolved, and of an uniform tex-

c ture,

ture, pour the whole out on a marble slab, and, when cold, the *chemical chalk* is prepared. This may be rendered harder by adding a fifth of shell lac to the above compound, during their fusion. Of the first composition, the chemical chalk, make a solution in distilled water; and to this solution add an equal quantity of a solution of shell lac in water by means of soda, and the *chemical ink* is formed. The solution of shell lac in water may be easily effected in a glazed pipkin, adding soda in sufficient quantity until the solution is complete: a boiling heat is necessary.

The German preparation of the chemical ink and chalk is as follows:—For the *ink*, they compound one ounce of tallow-soap, two ounces and a half of pure white wax, a quarter of an ounce of tallow, and a quarter of an ounce of lamp-black: the soap is scraped finely, and melted in an iron pot, and then the wax and tallow added.

added. During the operation the composition is well stirred, and, when quite hot, inflamed; the lamp-black is then added, and well mixed, by stirring the composition during the boiling. The composition is, when well boiled, poured out on a marble slab, and afterwards dissolved in distilled water, to make the ink. The *chalk* is prepared by melting together one ounce of tallow-soap, five ounces of white wax, a quarter of an ounce of tallow, one ounce of lamp-black. To this composition, when boiling, add five or six drops of pot-ash dissolved by the air: a strong ebullition is now produced, during which the ingredients must be stirred and kept on the fire until the froth has subsided, and the liquid mass become uniform; it may be now poured out on a marble slab, and, when cool, cut into slices for use.

To enable those who are inclined to practise this beautiful art to go through the

the whole of the process themselves, I have completed a very portable press, which will take an impression from a stone 15 inches by 10 inches, and may be manufactured at the low price of two guineas.—*Plate IV.*

In order to render this little Essay as useful as possible to those for whom it is intended, I will venture to offer the following instructions for drawing with the pen, as applied to landscape :—

Begin with the extreme distance, and use a pen that has a very fine nib, and a long slit to carry the ink : draw the contours of objects only as they appear in mass, as broad as possible, to give the effect of distance.

With a somewhat broader-nibbed pen put in the middle distance ; and, in addition to the simple contours of objects,

enter

enter a little into the detail of their larger masses.

On the foreground use a still broader pen, and give every object its local character and form in correct detail, which is the only mode of giving the effect of nearness, while it also tends to throw the other parts of the drawing back.

As there is no such thing as outline in nature, the lines by which we describe the forms of objects should be as much as possible confined to their shade side; and, as shadows always lie underneath, it is particularly to be remembered to begin by tracing the contours of masses at this part.

The shadows in general should be expressed by parallel straight lines which have no local character, but more particularly in the distance. On the foreground, the transparency of shadows will be better
preserved

preserved by tracing out the forms of the objects in a broader stroke of the pen. It adds to the harmony of the drawing, that the shade lines should all go one way, and parallel to the rays of light.

The sky may be done last; and little more is necessary than a few clouds, to prevent the disagreeable effect of so large a portion of the drawing being as it were a blank. Let it be remembered, however, that there is a rule for drawing these clouds; their shade tint must be produced by parallel lines gently waving and deviating from the line of the horizon.

The principle upon which the outlines of a pen-and-ink or pencil drawing in black and white are filled up, is called the mezzotento, or middle tint, or the tint between light and shade*: it is best produced by

* The ground on which the drawing is made being the light, the outlines the shade.

straight

straight parallel lines of different degrees of strength. This tint, however, is not used on the foreground, where the light should be in undiminished strength.

It is particularly recommended that the whole of the drawing should be made with as few lines as possible in the first instance. It is a perfection in drawing to give the local character of any object by as few touches as possible : and there is an advantage in this mode, in the opportunity it gives of promoting the effect of aërial perspective, by more amply making out the objects near to you, and where the strongest lights are supposed to fall in finishing.

The first state of a drawing is like the dead colouring of painting. The subsequent touches on the drawing bring it up to life, like the second and third paintings of a picture, which improve the lights, strengthen the shadows, and make out local character.

character. Indeed, it is a good plan to imagine that you are at first drawing with so little light that the contours of the masses can only be defined; then suppose a little more light, which exhibits them more in detail; and lastly, that sufficient quantity of light which makes every thing properly obvious.

To those who are well acquainted with the subject, these instructions are on my part a work of supererogation, but I trust not impertinently intruded. They are founded at least on just principles, and on so rational a theory, that the art of drawing from nature may be much assisted by them; and the drawings of those who apply them have a masterly character.

Printed by Macdonald and Son, 46, Cloth Fair, London.

NOTES TO THE TEXTS

References to page numbers are given in roman (upright) figures where they relate to the 1813 edition and italic figures where they relate to the 1816 edition.

2/6 but he took out no patent

A patent was taken out for lithography in 1801, but in the name of the inventor. Senefelder travelled to London in the winter 1800–1801 in order to obtain protection for his process in this country. He stayed in England for seven months and was looked after by Philipp André. The patent was granted on 20 June 1801: *A new method and process of performing the various branches of the arts of printing on paper, linen, cotton, woollen and other articles* (Patent No. 2518; Patent Roll C 210/81). The patent was yielded to Johann André, Philipp's brother, by an agreement dated 10 August 1801 (printed in part by F. Man, 'Lithography in England (1801–1810)', in C. Zigrosser, *Prints*, London, 1963, pp. 101–2). André's concern to keep the process secret was also mentioned by Senefelder who complained bitterly of being kept 'in a perfect seclusion from society, for fear of losing the secret' in the account he gave of his stay in London (*Complete course of lithography*, London, 1819, p. 37).

2/6 six impressions at half-a-guinea each

The publication referred to here is *Specimens of polyautography consisting of impressions taken from original drawings made purposely for this work*, London: published 30 April 1803 by P. André, Patentee, No. 5 Buckingham Street, Fitzroy Square, and J. Heath, No. 15 Russel Place, Fitzroy Square. The original intention was to publish six parts, each containing six lithographs, but André did not stay in England long enough to see it realized. Many of the leading artists of the day contributed, including Benjamin West, then President of the Royal Academy, Academicians Henry Fuseli, Thomas Stothard, and James Barry, and the Swiss artist Conrad Gessner. The earliest of these prints to bear a date was one by West which was drawn in 1801. For a list of the artists contributing to the *Specimens,* see F. Man, *op. cit.,* p. 128.

2/6 he was succeeded . . . by Mr. G. J. Volweiller [*sic*]

André returned to Germany in 1805. In 1806, after a lapse of eighteen months, he was succeeded as Patentee by G. J. Vollweiler, who had previously worked as assistant to Johann André in Offenbach. Vollweiler reprinted the first two parts of the *Specimens* and continued the series through to its completion between 1806 and 1807 (see F. Man, *op. cit.,* pp. 128–30, who prints a complete list of the contributors, and M. Twyman, *Lithography 1800–1850*, London, 1970, pp. 28–9).

3 Footnote

This is the only reference to such a re-printing I have come across. There is no indication that Bankes did re-publish the *Specimens*, though it is possible that the collection of prints bearing the title *Polyautographic Society, examples of forty original drawings,* which is recorded by Pennell (*Lithography & lithographers,* London, 1898, pp. 122–4) as being in the Victoria & Albert Museum, may be the result of a partial re-printing of the stones. Unfortunately this collection can no longer be traced, but the number of prints revealed by the title is consistent with publishing in multiples of five and twenty. Furthermore, Pennell records that it included the twelve prints of André's edition of the *Specimens.* It seems likely that Bankes obtained the stones of the *Specimens* through his connection with Redman, who had previously worked for both André and Vollweiler. In any event, his possession of them links him directly with the work of those who first practised lithography in this country.

4/7 Quarter-Master-General's Office

When Vollweiler returned to Germany in 1807 he sold the 'secret' of the process and the necessary materials for lithography to the Quarter-Master-General's Office for the sum of one hundred pounds. Lieutenant-Colonel Brown, who was in charge of the drawing office there, had seen specimens of lithography which convinced him of the usefulness of the process for military and official purposes. It seems that the first attempts he made in lithography were unsuccessful because he misunderstood or forgot part of the process, and that by chance one of his staff discovered Redman and made arrangements for him to help with the printing. The first successful production, a Plan of Bantry Bay, was published on 7 May 1808, and other work soon followed. On the appointment of Sir Willoughby Gordon as Quarter-Master-General in 1811, the process began to be used much more widely for the printing of maps, plans, and circulars, and by a number of Government departments. The press was given a considerable boost by the Peninsular War (1808–14) and plans for some of Wellington's campaigns were produced by lithography. (See T. Fisher, 'Curious specimen of polyautography, or lithography', *Gentleman's magazine,* vol lxxxv, October 1815, p. 297; *Foreign review,* vol. iv, 1829, pp. 48–9; Twyman, *op. cit.,* p. 33, 33n; S. G. P. Ward, *Wellington's headquarters: a study of the administrative problems in the Peninsula 1809–1814* (London, 1957).

5 support for himself and family

Redman's difficult circumstances (his poverty and family responsi-
bilities) were also referred to by Thomas Fisher when drawing attention
to the lithographic press Redman set up privately in London in 1815
('Curious specimen of polyautography, or lithography', *Gentleman's
magazine*, vol. lxxxv, October 1815, p. 297). A small card in the
Department of Prints and Drawings of the British Museum (190* b2,
f.2) which is lettered 'Dr. [possibly Dc. or De.] Redman Qr. Masr.
Genls. Office Horse Guards, Printer from Stone.' suggests that Redman
took on private work while employed at the Quarter-Master-General's
Office. Some printing of artists' drawings was certainly undertaken
there – though not necessarily in Redman's time – because the Ministry
of Defence Library copy of H. Rapp's *Das Geheimniss des Steindrucks*
(Tübingen, 1810) has a chalk lithograph of a girl's head pasted on to
the fly-leaf with the manuscript note 'Printed from Stone at the
Military Dépot, drawn by Mr. Marcuard. H. gds. 23d. Jany. 1815'.

5 settled in the city of Bath

Unfortunately, no more is known about Redman's press in Bath than
is revealed in the Introduction to this facsimile edition. I have been
unable to find any references to his move to Bath in local newspapers,
and he is not listed in Bath directories.

6/9 screw or rolling-press

For a discussion of the kinds of presses Bankes may have used for
lithography, see below, note to *p. 24* of the 1816 edition.

6/10 the *White-Lias*

The suitability for lithography of stone found in the neighbourhood of
Bath had been noted by Thomas Fisher some years before Redman
moved to Bath ('The process of polyautographic printing', *Gentleman's
magazine*, vol. lxxviii, March 1808, pp. 193–4). Stone was extremely
expensive to transport from Germany to England and the possibility
of finding suitable stone locally must have been a factor in Redman's
move to Bath. The extent to which he actually used local stone will
probably never be determined, but the portrait of Magliabechi which
he printed for insertion in the *Gentleman's magazine* of October 1815,
soon after moving back to London, is described in the accompanying
text (Fisher, *op. cit.*, p. 297) as having been made 'upon a piece of lias

stone dug out of a quarry in the neighbourhood of Bath . . .'. It cannot truthfully be said that the White Lias around Bath has 'precisely the same' qualities as the lithographic stone from the quarries in the Solnhofen region of Bavaria. When Hullmandel submitted a collection of lithographs he had printed from German stone to the Society of Arts in 1820, he commented that the White Lias of Bath answered tolerably well the purposes of lithography, but that it was too soft and porous, gave too few impressions, and was difficult to find in large enough sizes. In a footnote to his treatise, Hullmandel dismissed Bath (and Warwickshire) stones as 'totally unfit for chalk drawings' (*The art of drawing on stone*, London, 1824, note p. 2). Nevertheless, stone from the area around Bath continued to attract the attention of lithographers from time to time, even as late as the early years of the present century. Bankes must have realized that it was of more than local interest as it was the one item in his treatise relating to Bath which he chose to keep in the second edition. For a more detailed discussion of the use of the White Lias around Bath for lithography see M. Twyman, 'Lithographic stone and the printing trade in the nineteenth century', *Journal of the Printing Historical Society*, no. 8, 1972, pp. 11–15.

8/11 to change this for Lithography

The 1813 edition of Bankes's treatise, which was published in October 1813, contains what has hitherto been regarded as the first recorded use of the word 'lithography' in the English language (the word is also found on the title-page and on p. 7). The adjective 'lithographic' also appears in the book (on pp. 11, 12 and 17); the use of the word here precedes its use in the title of Barker's *Forty lithographic impressions of rustic figures* which was not published until December 1813. Since the word lithography appears in the title of Bankes's treatise, however, it first reached the public in the advance notices of the book which appeared in the *Bath Chronicle* (9 Sept. 1813) and *Bath and Cheltenham Gazette* (29 Sept. 1813). The adoption of the word by those associated with the process at Bath can probably be narrowed down to a period between July and September 1813. Advance notices of Barker's *Rustic figures* which appeared in the *Bath and Cheltenham Gazette* (21 April 1813) and *Bath Chronicle* (6 May and 22 July 1813) refer to 'Impressions from Drawings done by Himself on Stone Blocks'; the actual announcements of the publication which appeared in the *Bath and Cheltenham Gazette* (1 Dec. and 15 Dec. 1813) and *Bath*

Chronicle (25 Nov. and 16 Dec. 1813) after the publication of Bankes's treatise refer to 'Forty Lithographic [or Lythographic] Impressions'.

The words 'lithographie' and 'Lithographie' had been in fairly regular use in France and Germany for something like a decade beforehand, and this suggests that Bankes had some knowledge of continental lithography or publications on the subject (for a discussion of the early terminology of the process, see Twyman, *Lithography*, pp. 4–5). The word 'polyautography' was the one most frequently used to describe the process in England before the publication of Bankes's treatise, but thereafter the new word was rapidly adopted. It is worth noting that Thomas Fisher called his contribution to the *Gentleman's magazine* of October 1815 'Curious specimen of polyautography, or lithography' (vol. lxxxv, pp. 297–8).

It should be said that Bankes's reason for changing the name of the process seems rather odd from an etymological point of view as 'polyautography' more accurately defines the multiplication of an artist's own drawing than does the word 'lithography'.

11/14 *multiplied originals*, instead of spiritless copies

This point was made over and over again in the early literature of lithography. The claim that in lithography each impression is identical to the original drawing on stone is to be found as early as 1802 in France ('Extrait d'une lettre de Londres . . .', *Annales de chimie*, vol. xli, Paris, 30 nivôse an X^e [January 1802], pp. 309–10) and a year later in Germany (*Englische Miscellen*, vol. xiii, no. 1, Tübingen, 1803, pp. 62–5). The possibility of dispensing with the professional engraver was seen as one of the main attractions of the new process, and the slogan that lithographs are not reproductions but multiplications of an original drawing was repeated by most writers on lithography of the first quarter of the nineteenth century. The argument was countered very early on by the engraver John Landseer, who was not slow in recognizing the dangers of the new process to his own profession: 'The Stone-etching is calculated, perhaps beyond any art at present known, to render a faithful fac-simile of a painter's sketch. It is an accession to that sketch itself, if the artist choose to sketch on stone, of the power of multiplying itself to any number that may be required. I must at the same time remark to you, that it is *not* the painter's *sketches*, that it is most desirable to multiply, but his *finished performances*.' (*Lectures on the art of engraving*, London, 1807, p. 143).

The point made by Bankes about 'multiplying the drawings of our

best masters' was taken a stage further by W. S. Williams forty years later in a typically Victorian flight of fancy: 'If Lithography had been invented in the time of Raffaelle, and Michael Angelo and Leonardo da Vinci, we might have had the studies for the Prophets and Sybils in the Sistine Chapel, for the Frescoes in the Vatican, and for the heads in the Last Supper; and the Cartoons at Hampton Court would not have been left for Messrs. Linnell to copy in Lithography: as it is to be hoped they may. The engravings by Marc Antonio after Raffaelle are highly valued, and justly so; but what would not connoisseurs give for Lithographic Fac-similes of the sketches of these mighty masters, executed by themselves or the pupils of their respective schools.' ('On lithography', *Transactions of the Society of Arts for 1846–7*, vol. 56, p. 240).

The issue as to whether a lithograph should be considered a work of art or a reproduction was taken up again in the late nineteenth century when the *Studio* coined the word 'auto-lithograph' to describe a lithograph drawn by the artist himself on stone or transfer paper (vol. 3, 1894, p. 85).

11 Mr. Thomas Barker's intended publication

The work referred to here is *Forty lithographic impressions from drawings by Thomas Barker, selected from his studies of rustic figures after nature* (Bath, December 1813). The drawings are all ink lithographs and the work was published by subscription in not more than 200 copies (117 subscribers are listed). The Advertisement records that the drawings were made on the stone 'without the smallest alteration in character or attitude' and claims that 'The capacity of the Lithographic Art to produce fac similes from Drawings, has been the great inducement to employ its powers in the present Work, which will therefore maintain all the freedom and spirit the original Sketches might possess.'

Thomas Barker (1769–1847) was one of a number of successful artists who worked in Bath in the eighteenth and early nineteenth centuries. His family stemmed from Wales and came from there to settle in Bath around 1782. In Bath the young Thomas came under the patronage of a wealthy coach builder, Charles Spackman, who arranged an exhibition of his work in the spring of 1790 and then supported him for three years in Rome. On his return to England, Barker worked for a time in London and began exhibiting at the Royal Academy. After 1800 he lived in Bath, where he became a prolific and successful artist and amassed a considerable fortune from his work. Originally he

modelled himself on the style of Gainsborough, and it is said that some of his best works masquerade today under Gainsborough's name, but the rustic scenes which made him popular in the nineteenth century are nearer in style to Morland and others of his generation.

Barker contributed lithographs to both editions of the *Specimens*, and Man lists five lithographs of his (*op. cit.*, nos 16–20) which were produced during the period when André and Vollweiler were working in London. Other lithographs by him are to be found in the Poly-autographic Albums of the British Museum (Department of Prints and Drawings, 190* b1, 2). In addition to being well established as a painter, Barker was therefore one of the few artists in England to have had reasonable experience of lithography when he took the opportunity to make use of the lithographic press recently established in Bath. Indeed, it is quite possible that Barker had something to do with Redman's move from London to Bath. No comprehensive study of Thomas Barker has yet been written. For brief accounts of his life and work see Bryan's *Dictionary of painters and engravers* and the intro- duction by J. Hayes to the catalogue of the exhibition *Barker of Bath* (Victoria Art Gallery, Bath, 1962); for a discussion of his lithographic work see T. Winkler, 'Thomas Barker of Bath', *Börsenblatt für den Deutschen Buchhandel*, no. 99, December 1965, pp. 2650–4.

The following advance notice of Barker's *Rustic figures* appeared in the *Bath and Cheltenham Gazette* of 21 April 1813 and (with minor changes in punctuation and capitalization) in the *Bath Chronicle* of 6 May and 22 July: 'Mr. T. Barker is about to publish, by Subscription a series of Impressions from Drawings done by Himself on Stone Blocks; a method which will ensure to the Prints all the Spirit and Effect of the Originals. – The whole will consist of Forty Subjects of Rustic Figures From Nature, and will be printed on China paper, neatly stitched in boards. The price to Subscribers, Three Guineas; Non-Subscribers, Four Guineas. To be paid on delivery of the Work, which will be completed early in July next. Names of Subscribers will be received at Upham and Godwin's Libraries, and at Colnaghi and Ackermann's, London; where Specimens of the work will be shortly ready for inspection. A list of Subscribers will be printed with the work.'

The actual publication of the work was prematurely announced in the *Bath Chronicle* (25 Nov. 1813) and *Bath and Cheltenham Gazette* (1 Dec. 1813), and the following note appeared in the *Bath and Chelten- ham Gazette* of 15 December 1813: 'This Day Is Published, (And not

on December 1st, as before advertised) Forty Lithographic Impressions, From Drawings by Thos. Barker, Selected from his Studies of Rustic Figures after Nature. Price, to Subscribers, Three Guineas; to Non-Subscribers, Five Guineas each. Only Two Hundred Copies will be printed; the greater part of which are subscribed for.' The *Bath Chronicle* (16 Dec. 1813) also carried a notice of the publication.

12 landscape scenery and studies of figures made in Italy

The second lithographic work of Barker's to be published in Bath was *Thirty two lithographic impressions, from pen drawings of landscape scenery, by Thomas Barker* (Bath, 1814). This is a more remarkable work than the *Rustic figures* in many respects. The drawings display a freedom in handling the pen and an intensity of feeling for nature that have rarely been equalled in lithography. Miss F. Waring had drawn a set of rather hesitant chalk lithographs which were published ten years earlier with the title *Twelve views of Scotland* (London, 1803), but Barker's *Landscape scenery* can be considered the first important collection of landscape lithographs to be published in this country.

In the Advertisement to the publication Barker stated that the studies were chiefly of British scenery and that he thought it necessary to explain this 'in consequence of its having been notified to the Public that a series of Italian Landscapes was intended.' – a comment that may well have been prompted by the somewhat ambiguous reference to it in Bankes's treatise. The original intention, as revealed by Barker in *Rustic figures*, was to publish the work in four numbers, each costing $1\frac{1}{2}$ guineas, the thirty-two subjects being 'drawn with the pen in the manner of free Etchings'. In the event, the work was published complete at six guineas. Only fifty copies were produced, and the work was described as being 'Printed under the Direction of Mr. Barker, by D. Redman'.

In view of the small size of the edition, it is somewhat surprising that Barker's *Landscape scenery* was advertised as widely as it was. The *Bath Chronicle* (12 May 1814) carried a notice of it, and the *Bath and Cheltenham Gazette* printed virtually the same advertisement which was inserted in at least four issues (11, 18, 23 May and 1 June 1814). Apart from anything else, the notices in the *Bath and Cheltenham Gazette* provide a salutory warning not to take announcements of precise dates of publications too seriously: 'Lithography. This Day is published, price Six Guineas in extra Boards, Imperial Quarto, Thirty-

Two Impressions from Pen Drawings of Landscape Scenery (Chiefly British), by Thomas Barker. Sold by Upham, bookseller, Walks, Bath; and Messrs. Colnaghi and Co. Cockspur-street, London; – of whom also may be had, Barker's Rustic Figures. N.B. Fifty Copies only of the Landscape Scenery will be published.'

Some of the stones used for the printing of *Rustic figures* and *Landscape scenery*, with Barker's drawings still on them, have recently been traced. They have all been photographed and will be described in a forthcoming issue of the *Journal of the Printing Historical Society*.

18 *Example* 1 *in plate* 2

It is not clear what this and the following plate references refer to. No plate of Bankes's treatise I have seen is numbered; moreover, the landscape prints (A, D and E) which are to be found in some copies do not seem to relate to the text on pages 18–19 (which leads one to expect either a composite plate with progressive stages of the same image, or a single image with three clearly defined parts). All references to '*plate* 2' were excluded from the 1816 edition.

20/25 parallel straight lines

The recommendations in this and the following paragraph clearly relate to the traditional syntax of copper-engraving and etching, even though Bankes insisted in the 1813 edition (p. 17) that artists should draw on stone with the same freedom and spirit as they would when drawing on paper and that they should on no account 'give their drawings any thing like the character of engraving . . .'.

8 saponaceous

The change here from the word 'oleaginous' (1813 edition, p. 5) reflects Bankes's better understanding of the composition of the ink, though it is doubtful whether it was in the direction of greater precision of meaning. Oleaginous [OED: Having the properties of, or containing oil; oily, fatty, greasy] and saponaceous [OED: Of the nature of, resembling, consisting of, or containing soap] have different meanings, neither of which is incorrect in this context. Numerous recipes for lithographic drawing ink were published in the nineteenth century, nearly all of which involved a combination of wax, tallow, soap and lampblack, and some of them shellac as well. The composition of soap

varied considerably from one manufacturer to another in the nineteenth century (as, no doubt, it does today), but in the main it consisted of fatty acids in chemical combination with alkalis such as soda, potash, and ammonia. The principal purpose of the soap in lithographic ink and chalk was to make the other ingredients soluble in water.

14 the characters of the oriental languages

Lithography was being used successfully in Germany by this time for the multiplication of handwritten circulars and similar work, and was already in use for such purposes at the Quarter-Master-General's Office in Whitehall (see above, note to p. 4; below, second note to *p. 14*). The earliest example known to me of the application of lithography to the reproduction of what were then called oriental languages is a single print by Thomas Fisher in the British Library. This bears the title 'A Collection of all the Characters Simple and Compound with their Modifications, which appear in the Inscription on a Stone found among the Ruins of Ancient Babylon . . .' and the imprint 'Collected, Etched and Published June the 1st. 1807 by Thos. Fisher'. Three years after the publication of the second edition of Bankes's treatise, the versatility of lithography for the multiplication of non-Latin scripts was demonstrated by G. Hunt in his *Specimens of lithography* (London, 1819). This small book, which was printed throughout in lithography by C. Marcuard in 1818, contains examples of Arabic, Bengalee, Chinese, Cufic, Hebrew, Persian, Sanscrit, Syriac and other scripts, and Hunt records in his introduction that the object of the publication was 'to enable the Orientalist to form some judgment with what effect Lithography may be applied to Eastern Literature.' In the same year publication began of Thomas Young's much more ambitious and influential book, *Hieroglyphics, collected by the Egyptian Society* (London, 1819–28). This folio work contains impressive plates which were printed by the best lithographers of the day – Ackermann, Hullmandel, Netherclift, and Rowney & Forster – and must have done much to encourage the use of lithography for the reproduction of texts in non-Latin scripts.

14 on a paper varnished with size or strong gum

Bankes made no mention at all of the use of transfer paper in the first edition of his treatise. It seems likely that this branch of lithography was little understood in England and was practised rarely, if at all, in

this country when his book went to press in 1813. Thomas Fisher referred to the possibility of transferring a subject from paper 'if nothing but a coarse sketch or outline is intended' ('The process of polyautographic printing', *Gentleman's magazine*, vol. lxxviii, March 1808, p. 194), but he made it clear that he had no direct experience of the process. The article on lithography in the *Foreign review* of 1829, which is most informative on the activities of the press at the Quarter-Master-General's Office, records quite specifically that the transfer method 'was first practised in England at the Horse Guards in July 1813' (vol. iv, p. 49). If this was so, Redman would have left for Bath before having had a chance to master the process of transfer lithography.

15 trace over them with the prepared ink or chalk

While most of the observations made by Bankes can be found in other early accounts of lithography, I know of no other reference to this particular method of working.

18 vitriolic acid

A number of different acids could be used in lithography for the operation usually known as 'etching', and Bankes referred to nitric acid in this context (p. 15) in the 1813 edition. Nitric acid was the acid most commonly used for this purpose throughout the nineteenth century, while vitriolic acid (known today as sulphuric acid) was rarely used. Senefelder wrote of sulphuric acid that it was 'of great use, if a strong etching acid is not required; but where this is the case, it cannot be used, as this acid in dissolving the surface of the stone, changes it into gypsum, which covers the stone, and prevents the acid from acting any more on it.' (*Complete course of lithography*, London, 1819, p. 139). About a century later, N. Montague stated that 'Its action on stone is to form a crumbling surface which is of no use whatever.' (*The art and practice of printing. Vol. III: Lithography*, London, nd., p. 114).

18 take up the alkali

Though small in scale, this addition is perhaps one of the most significant differences between the texts of the two editions (see 1813 edition, pp. 15–16). The writers of early accounts of the process (including Senefelder in his specification and treatise, and Bankes in the 1813 edition) made the mistake of emphasizing the imperceptible

lowering of the surface of the stone which results from the action of the acid. Only at a later stage did lithographers in general realize that a chemical action took place in the ink itself which was essential to the process. Bankes's brief mention of it here is the earliest reference I have come across to the rendering of the ink insoluble by the action of the acid. For a discussion of the function of the 'etch' in lithography, see W. D. Richmond, *The grammar of lithography* (London, 9th ed., nd, pp. 69–71).

20 rubbed smooth with a piece of pumice-stone

The changes made to the passage relating to the correction of a drawing on stone (see 1813 edition, p. 17) are a further indication of Bankes's better understanding of the practical details of lithography when he came to prepare the second edition for publication.

21 The ink

I have been unable to find a similar description of the composition of the drawing ink and chalk, and I think it must be assumed that this account stems from Bankes's own experience. Many different recipes for lithographic drawing ink and chalk were published; they all contained the same basic ingredients (see above, note to *p. 8*), and the precise composition depended, among other things, on the kind of work to be undertaken. There are brief references to Bankes's lithographic ink in a MS notebook on lithography compiled in his youth by the geologist John Phillips ('Lithography', f.29, Phillips MS Collection, University Museum, Oxford). Bankes's ink is referred to in entries dated 27 April 1819 and May 1819 in terms which suggest that it was on sale; no recipes are given for it.

22 The German preparation of the chemical ink and chalk

Strictly speaking, of course, Bankes should not have referred to *the* German preparation of the ink and chalk. Senefelder, for instance, provided some twenty recipes for lithographic drawing inks and chalks. Bankes's account of the ingredients and preparation of the ink and chalk follows very closely information printed in Heinrich Rapp's *Das Geheimniss des Steindrucks* (Tübingen, 1810), pp. 42–6, and the article 'Ueber den Steindruck, nach eignen Erfahrungen', *Neues Magazin aller neuen Erfindungen, Entdeckungen und Verbesserungen*, vol. i, no. 2, 1810, pp. 72–4. A copy of Rapp's treatise, the first independent

work on lithography, was acquired by the Quarter-Master-General's Office before 1813 and is listed in the *Catalogue of books in the Library of the Military Depot, Q.M. Genls. Office* which was printed in that year. It seems reasonable to assume therefore that Bankes came across Rapp's treatise through his contact with Redman, who must surely have known of the book while he was at the Horse Guards, even though he may not have been able to read and understand it. The Ministry of Defence Library still holds this copy of Rapp's treatise, and no other copy of this edition has yet been traced in this country. A copy of the Schweinfurt edition of Rapp's treatise, which also dates from 1810, is preserved in the St Bride Library, but the text of this edition differs from that of the Tübingen edition in such a way that it is clear that it could not have been the source for Bankes's account of the German preparation of the ink and chalk.

24 I have completed a very portable press

The plate referred to here must have been the earliest illustration of a lithographic press to appear in an English publication. Though no copy of the 1816 edition with its plates has been traced, we are able to form some idea of the construction of the press from Bigmore & Wyman's brief description of the plate in the missing British Museum copy. The description runs: 'It consisted of two cylinders, the upper one being turned by a handle, the stone passing between them; a screw in the head of the framework giving increased pressure. The arrangement was similar to that of the domestic wringing or mangling machines now in common use.' (*A bibliography of printing*, London, 1880, p. 34).

Bigmore & Wyman's verbal description is confirmed by a contemporary drawing of Bankes's press made by the geologist John Phillips. I am grateful to Mr J. M. Edmonds of the University Museum, Oxford, for drawing my attention to a MS notebook compiled by Phillips in 1819 ('Lithography', Phillips MS Collection, University Museum, Oxford). This includes records of the experiments the young John Phillips made in connection with the lithographic press he had recently set up in London. It also includes his observations on some of the presses that had been designed for lithographic printing, and contains the drawing of Bankes's press reproduced on the opposite page.

This drawing accords closely with Bigmore & Wyman's description of the plate in Bankes's treatise and may well have been copied from

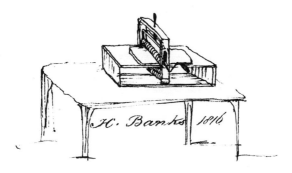

it. In a note of 18 February 1819 (f.22) Phillips records that Bankes's press was 'Objectionable on account of its weakness', that it incorporated an 'imperfect method of pressing down the rollers', and that it was 'most fit for small light Drawings'.

Very little is recorded about the lithographic presses in use in England before about 1820. James Wyld, who worked as a draughtsman for the lithographic press at the Quarter-Master-General's Office, claimed in 1820 to have had experience of 'no less than five different presses, on various constructions . . .' (letter of recommendation printed in [J. Ruthven], *A concise account of lithography*, London, 1821, p. 16). In addition to the drawing of Bankes's press, John Phillips includes in his notebook drawings of his own press, that designed by William Smith (his uncle), a portable scraper press similar to Senefelder's, and a scraper press of foreign design used by Redman. The very first presses used in England for lithography seem to have been pole presses similar to the version illustrated in the English patent specification, which shows a cylinder attached to the end of the beam (the one surviving pole press in the Deutsches Museum, Munich, and illustrations of German pole presses suggest that the version with a scraper attached to the beam must have been more common in Germany). J. T. Smith described the press on which the lithograph for his *The Antiquities of Westminster* was printed as being 'similar to that used by calenderers, for glazing of linen' (London, 1807, p. 49) and, in a general discussion of the process, Thomas Fisher described an impression as being taken 'by passing over the whole an iron or brass cylinder under the pressure of a beam suspended from the roof of the apartment'. ('The process of polyautographic printing', *Gentleman's magazine*, vol. lxxviii, March 1808, p. 194).

Bankes seems to have rejected, or been unaware of, the pole press. In the design of his own press he appears to have been working along similar lines to those followed by Senefelder at the very outset of lithography. Senefelder's experiments with presses began with attempts to adapt existing copper-plate presses, but even before he had perfected the process itself he had come to realize the importance of applying pressure by means of a scraper, which had greater flexibility than a cylinder and was therefore less likely to break the stone. Nearly all successful lithographic presses of the first half of the nineteenth century (apart from portable presses) made use of a scraper to apply pressure to the stone. For a general discussion of lithographic presses in this period and further information on points raised in this note, see M. Twyman, 'The lithographic hand press 1796–1850', *Journal of the Printing Historical Society*, no. 3, 1967, pp. 3–50.

The portable press developed by Bankes closely resembled the presses of John Ruthven (1820) and Albert Waterlow (1850), though in both of these the handle was attached to the lower cylinder. Senefelder's portable press, which worked by moving a scraper along a screw, does not seem to have been perfected until 1819. Portable presses, whether of the scraper or cylinder variety, were unlikely to produce good prints from anything but the simplest of ink lithographs. Bankes does not state that the plates for the second edition of his treatise were printed on his portable press but, if they were, this might account for the poor quality of them remarked upon by Bigmore & Wyman.

The references to a screw or rolling-press elsewhere in the text of Bankes's treatise (1813 edition, pp. 6, 16; 1816 edition, *pp. 9, 19*) are somewhat surprising in view of the fact that we can be virtually certain that the first lithographers in England used a pole press. No rolling-press can be used to print from lithographic stone without some adaptation, and the screw (or copying) press is unlikely to produce anything more than a weak impression of a simple line image. The references to a screw or rolling-press can be explained in the case of the 1813 edition by Bankes's lack of experience of lithography, but their retention in the 1816 edition without further explanation is very odd.

There remains the possibility that when Bankes wrote 'a screw or rolling-press' or 'a rolling or screw press' (both versions are used), he had in mind a press like his own cylinder press which had a pressure screw in the head of the framework.